BLAKE'S *JOB*

BLAKE'S *JOB*

William Blake's *Illustrations of the Book of Job*

WITH AN INTRODUCTION AND

COMMENTARY BY

S. FOSTER DAMON

Published for
BROWN UNIVERSITY PRESS
by
UNIVERSITY PRESS OF NEW ENGLAND
Hanover and London

UNIVERSITY PRESS OF NEW ENGLAND

BRANDEIS UNIVERSITY

BROWN UNIVERSITY

CLARK UNIVERSITY

DARTMOUTH COLLEGE

UNIVERSITY OF NEW HAMPSHIRE

UNIVERSITY OF RHODE ISLAND

TUFTS UNIVERSITY

UNIVERSITY OF VERMONT

LIBRARY OF CONGRESS CATALOGING IN PUBLICATION DATA

Blake, William, 1757-1827.
 Blake's Job.

 1. Blake, William, 1757-1827. 2. Bible. O.T. Job—
Illustrations I. Damon, S. Foster (Samuel Foster),
1893-1971. II. Title.
[NE642.B5A4 1982a] 769.92′4 82-13585
ISBN 0-87451-241-7 (pbk.)

ACKNOWLEDGMENTS

In 1935 the Pierpont Morgan Library, New York, issued *Illustrations of the Book of Job*, by William Blake, with magnificent reproductions of all the water colors, drawings, and engravings, and an introduction by Laurence Binyon and Geoffrey Keynes. To this publication I am deeply indebted.

Like all Blake scholars I am also deeply indebted to Joseph Wicksteed's work, *Blake's Vision of the Book of Job* (London and New York, 1910; second edition revised and enlarged, 1924). Wicksteed was the first really to understand Blake's idea, and was the first to show us how to read any and all of Blake's pictures.

I am grateful to Rabbi William G. Braude for information about the Hebrew text. Alvin Rosenfeld has also been of assistance.

Through the courtesy of the Harvard College Library, Department of Printing and Graphic Arts, it has been possible to reproduce in this book the proof state set in the Harvard College Library of the first edition (1825) of *Illustrations of the Book of Job*.

S. FOSTER DAMON

Brown University

CONTENTS

BLAKE'S *JOB*

NOTE: For all quotations from Blake's own writings, see *The Complete Writings of William Blake*, edited by Geoffrey Keynes (London, 1957; revised edition, London, New York, and Toronto, 1966), hereafter referred to as "Keynes."

INTRODUCTION

THE BOOK OF JOB was one of the greatest books ever written; here it is interpreted by one of the greatest of illustrators.

William Blake was exceedingly precise when he illustrated. He studied the text so carefully that he found significance even in such matters as emphases: he knew why the Lord ended his address with such elaborate accounts of Behemoth and Leviathan, and why the book ends with particular note of Job's three daughters. Blake also added details to indicate his own explanations. Therefore one must *read* his pictures, symbol by symbol, to discover those ideas. Blake himself wrote: "I intreat, then, that the Spectator will attend to the Hands & Feet, to the Lineaments of the Countenances; they are all descriptive of Character, & not a line is drawn without intention, & that most discriminate & particular. As Poetry admits not a Letter that is Insignificant, so Painting admits not a Grain of Sand or a Blade of Grass Insignificant—much less an Insignificant Blur or Mark" (*A Vision of the Last Judgment*, Keynes, p. 611).

Furthermore, Blake warns us, in the inscriptions on his very first illustration, that his pictures are not to be understood literally: "The Letter Killeth, The Spirit giveth Life" (II Corinthians iii : 6). They must be "Spiritually Discerned" (I Corinthians ii : 14). Job's sons are not killed in the flesh: they are dead only to their father, and they reappear at the end. The devil who destroys them is not an independent angel but the Accuser in Job's own brain. The boils which infect him are not a mere skin disease but a disease of his own soul.

In fact, the whole drama is enacted in Job's soul. His wife is part of him, his inspiration, his feminine aspect (which Blake elsewhere called an Emanation), who shares his errors. His children are his creations, his deeds, his joys. The accusing friends are also part of him, as they speak for his submerged sense of guilt. His devil is the Accuser within him, and even his God is his own creation, his own ideal, made in his image, his Selfhood, and not the true God at all.

The nature of this false God is defined in an episode in Blake's *The Four Zoas* (iii : 44–104) and repeated in his *Jerusalem* (29 : 33–83), where Albion, who is mankind, goes through some of Job's experiences. His soul is darkening, and from his wearied intellect rises his Shadow "of living gold, pure, perfect, holy . . . a sweet entrancing self delusion." Albion accepts his Shadow as God, and prostrates himself: "O I am nothing when I enter into judgment with thee." As a result of this vision of purity, Albion rejects all his emotional life (Luvah and Vala), whereupon Luvah smites Albion with Job's boils and closes his five senses (as in Illustration VI).

Blake's symbols in *Illustrations of the Book of Job* are simple but never obtrusive; indeed, they were mostly overlooked until Joseph Wicksteed published his *Blake's Vision of the Book of Job* (London and New York, 1910; second edition revised and enlarged, 1924). Wicksteed's most important discovery was the significance of right and left—symbols fixed in our language and deep in our subconscious. The right hand or foot is the good, the spiritual; the left is the material, the legal, even the wrong. Thus the messengers of Job's material disasters arrive left foot first (Illustration IV); for a legal reason Job with his left hand gives half of his last loaf to a beggar (V); Satan's left hand pours the vial of boils (VI); the friends arrive left foot first (VII); Eliphaz points with his left hand to his false god (IX); Satan's left foot shows the cloven hoof (XI); and so forth. But when the true God descends toward man, he shows his right foot (XIII, XIV, XVII), while Job aspiring also shows his right (V).

3

INTRODUCTION

The contrast between the books of Law and the scrolls of Inspiration is carried through from the first illustration to the last. Law is essential, but when it is adopted as the sole guide it becomes hostile and life becomes unbalanced. Therefore, in Illustrations I and II, Job and his wife hold the books by which they are raising their family, and Job's God holds a book on his lap. In Illustration V, this God strives to stay on his throne by clinging to a closed book in his right hand; then, in Illustration XVI, when the true God is restored to his position, he holds the book open, but with his left hand, while he blesses the couple with his right. Contrasted with the books are the scrolls, which represent the instinctive life. They are Job's good deeds, which he has never considered of value but which, in Illustration II, the angels offer to God in Job's defense; meanwhile the eldest son, who is living his life in his own way, also holds a scroll. The scrolls in the margin of Illustration XVIII represent Blake's own poems. In the last illustration (XXI), the only book visible is a slender volume, apparently a songster.

The architecture is defiantly anachronistic. Blake used the Gothic for the true religion—the essence of Job's nature—the druidic cromlechs for the false, and the classical for the state of reason; while the Whirlwind (Illustration XIII) and its allied creation, art (Illustration XX), seem to be in a Renaissance palace. Closely related to the human characters are certain architectural forms which to Charles Eliot Norton and to Joseph Wicksteed, independently, suggested crosses (see Wicksteed, *Blake's Vision*, 1924, p. 130, n. 3). As Blake some time earlier had rejected the cross as the symbol of the true religion, these crosses represent the false, that of belief in punishment for sin. In Illustrations IV and VII, they stand over Job and his wife; then over the arriving friends (VIII); over the wife, when she momentarily doubts her husband's innocence (X); and again over the accusing friends (XII). In Illustration XIX they reappear, now broken, behind Job and his wife.

Most obscure are the seven angels on the title page. Blake identified them with the seven Eyes of God: in the Bible they are the "seven . . . eyes of the Lord, which run to and fro through the whole earth" (Zechariah iv:10), and also the seven eyes of the Lamb, "which are the seven Spirits of God sent forth into all the earth" (Revelation v:6). Practically, they represent the whole course of human thought in its search for an ideal by which to live. In a system that Blake developed in his epics, the Eyes, or angels, form the Path of Experience; they stand for a sequence of "states" established by the Divine Mercy so that fallen man, if he persist, shall find his way back to Eternity and the true God. Just as each period of life has its own errors and one matures by growing out of one period into another, each state represents a stage in the overcoming of an error: "to be an Error & to be Cast out is a part of God's design" (*A Vision of the Last Judgment*, Keynes, p. 613). Thus the seven angels have innocent faces and some bear scrolls. In *Illustrations of the Book of Job* the five states are: Innocence (I–II); Experience (III–VII); Revolution (VIII); The Dark Night (IX–XII); and The New Life (XIII–XXI). Job must pass through each of these stages until he exposes his false God and finds the true one. (See Table, opposite.)

Except for Jesus, these angels appear only on the title page. The states that they symbolize are the foundation of the book, but like most foundations are hidden below the ground, as it were. Blake named these angels elsewhere (*The Four Zoas* viii:398–406; *Milton* 13:17–27; *Jerusalem* 55:31–32). On the title page of his *Job*, the topmost angel, descending from the right, is Lucifer, the state of man as he enters this world: in this book, Job himself at the beginning of the Path of Experience. Lucifer is the only angel who does not bear a name of God. He is the baby, innocent, ignorant, inexperienced, and completely self-centered: "Man

4

TABLE OF ILLUSTRATIONS AND THEIR CORRESPONDENCES

ILLUS-TRATION	CYCLE	STATE	EYE	EVENT	CONTRARY
I	First	Innocence	Lucifer (Selfhood)	The sun sets	XXI
II				The Accuser enters heaven	XVI
III		Experience	Molech (Executioner)	Job's sons are lost	XX
IV				Messengers report the disasters	XIX
V			Elohim (Judge)	Job gives to a beggar (False charity)	XIX
VI				Job's senses are closed	XIV
VII	Second		Shaddai (Accuser)	The friends mourn Job's misfortunes	XIX
VIII		Revolution		Job curses his existence	XVIII
IX		The Dark Night	Pahad (Terror)	God appears as nightmare	XVII
X				The friends mock Job	XVIII
XI			Jehovah (Law)	The false God is revealed	XIII
XII				Elihu suggests future revelations	XV
XIII		The New Life	Jesus (Redemption)	The true God is revealed	XI
XIV	Third			Job's senses are opened	VI
XV			Jehovah	The subconscious is revealed	XII
XVI			Jesus	The Accuser is cast out	II
XVII			Pahad	God appears as friend	IX
XVIII			Shaddai	Job prays for his friends	VIII, X
XIX			Elohim	Job receives from friends (True charity)	IV, V, VII
XX			Molech	Job's daughters are recovered	III
XXI			Lucifer	The sun rises	I

is born a Spectre or Satan & is altogether an Evil, & requires a New Selfhood continually"
(*Jerusalem* 52, Keynes, p. 682). Molech—once worshiped in Israel as Malak, to whom the first-
born were sacrificed—is the second angel (just below Lucifer), because his first blind attempt
to solve the problems of life is to destroy anything that opposes his desires. He is the Execu-
tioner, who initiates the infernal system of inverted justice; he fails through impatience. The
third angel, below Molech, is Elohim, the Judge and definer of guilt. He is the first to show a
scroll, for with him begins some awareness of others. He fails through weariness. The fourth
angel is Shaddai, who still imputes guilt to others, and fails through anger. He looks backward
and is the lowest point in the flight of angels; but once the imputing of guilt to others is
passed, the remaining angels fly upward. The fifth is Pahad, bewilderment at the horrors of
justice; he fails through terror. The sixth angel is Jehovah, the lawgiver, who formulates the
moral system; he becomes leprous (*The Four Zoas* viii: 405; *Milton* 13: 24). The seventh an-
gel, with upright wings, is Jesus, who looks inward to the spiritual world; he rejects the whole
concept of Sin and Guilt, and abrogates the entire system by the Forgiveness of Sins, by sac-
rificing himself for Lucifer; he thus opens the way to Eternity.

Blake was always a systematizer. He saw clearly that spiritual causes have to produce spir-
itual results; therefore illustration follows illustration in a significant order. The course of the
seven angels provides the structure and meaning of the book: the twenty-one illustrations,
based on the angels, progress in three cycles of seven (I–VII, VIII–XIV, and XV–XXI). In
the first two cycles, the illustrations are paired, with two successive illustrations for each an-
gel. Thus Illustrations I and II (Lucifer) show Job in his innocent ignorance; Illustrations III
and IV deal with the destruction of his sons; Illustrations V and VI (Elohim) exhibit the
wrongness of his legal charity and the closing of his senses. Illustration VII, the first of the
next pair (Shaddai), ends the first cycle of seven with the arrival of Job's accusing friends; the
other half of this pair begins the second cycle, with the outbreak of Job's wrath. The fifth
pair, Illustrations IX and X (Pahad), reveals the horror of the God of Eliphaz; the sixth pair,
XI and XII (Jehovah), identifies this God as Satan; the seventh pair, XIII and XIV (Jesus),
ends the second cycle with the revelation of the true God and the spiritual nature of man.

In the third and last cycle the order of angels, or Eyes, is reversed, and the errors shown in
preceding illustrations are corrected; here there is only one illustration for each angel. Though
Blake was, as we have said, a systematizer, he seldom if ever presented his system completely
and mechanically: he had an annoying way of omitting a factor, or introducing variations, so
that his reader must start thinking again. Thus Jehovah (Illustration XV) precedes Jesus (Il-
lustration XVI), avoiding three successive illustrations devoted to Jesus; and the reverses or
contraries of Illustrations IV and VII could be disputed. Furthermore, the reversals actually
begin in Illustration XIII, with the New Birth.

Most of these reversals are obvious enough. Illustration XIII reveals the true God instead of
the false (XI); XIV shows the opening of the senses, which had been closed in VI; XV is the
revelation of the subconscious, at which Elihu had hinted (XII); in XVI the Accuser is cast
out from the heaven which he had entered in II; XVII (Pahad) reveals God as a friend in-
stead of a nightmare (IX); in XVIII (Shaddai) Job prays for the friends who had mocked
him (X), and thereby also reverses his wrath (VIII); XIX (Elohim) contrasts the true charity
with the false (V), and the arrival of gift-bearers with the painful arrivals (IV and VII); in
XX (Molech) the recovery of the daughters counterbalances the loss of the sons (III); and
finally in XXI (Lucifer) the sun, which had set in I, rises once again.

The finding of the true God is also the finding of one's own true individuality. Man is born

a Lucifer, whose central impulse is Pride. Job must recognize and humble his secret pride in being the greatest man in the East before his Humanity can awake. Yet this humility is not the humbling of his Individuality; only a false God can demand such a sacrifice: "If thou humblest thyself, thou humblest me" (Blake, *Everlasting Gospel c* : 39). Job has sensed something of this: "Though he slay me, yet will I trust in him: but I will maintain mine own ways before him" (Job xiii : 15). And Man, who began as the first Eye of God, becomes the Eighth, his real Humanity.

The Book of Job was written to attack the vulgar error that misfortunes are punishment for sin. Such is the contention of Job's friends, and for this idea the Lord denounces them. But how then account for Job's sufferings? Why should that "perfect" man so suddenly be plunged from the height of fortune to the depth, and for no fault of his own? The answer as commonly understood is that there was an arrangement between God and his servant Satan to test Job's fidelity, an arrangement made quite independently of Job himself.

Such an interpretation was to Blake unsatisfactory. Who was this Satan, who introduced doubt and guilt into Job's heaven? He was the *diabolus*, the Accuser of Sin. Job's prime error was admitting this Accuser into his heaven; and from this Satan all the disasters proceed. Only a false God would ever have listened to him. Once these points are settled, everything becomes clear. Job's disasters are not punitive but educational. They rouse Job from his complacent submissiveness to tradition, and start him on his search for the true God.

Illustrations of the Book of Job was Blake's third attempt, and his most successful, to produce a book without text of his own. His first attempt to convey his message primarily by a series of pictures was *The Gates of Paradise* (1793), to which he subsequently added explanatory verses (*ca.* 1818). He also illustrated an edition of Robert Blair's poem *The Grave*, which appeared in 1808. Although produced while Blake was still working on his most obscure book, *Jerusalem, Job* is perhaps his most lucid.

Blake's early and prolonged interest in the trials of Job is proved by a variety of drawings, paintings, engravings, quotations, and comments, starting about 1785. In *The Marriage of Heaven and Hell* he made the startling statement that the idea of *Paradise Lost* is the same as that of the Book of Job, but that Milton so misunderstood the meaning that his Messiah is really Job's Satan. About 1820 Blake made for Thomas Butts the first set of water colors illustrating the entire book. In 1821 he made a second set for John Linnell, and then a third, smaller set for one of Linnell's pupils. The engravings, which are reproduced here in full scale, were then commissioned by Linnell. They are dated March 8, 1825.

COMMENTARY AND ILLUSTRATIONS

TITLE PAGE

A flight of seven angels descends, then rises again, corresponding to the underground course of the sun, which sets in Illustrations I–VII but rises again in Illustration XXI. These angels symbolize the Path of Experience, the states through which Job passes, and form the structure of the book.

As the angels have been given detailed explanation in the Introduction, the following is only a brief summary; proceeding clockwise from the right, they are: (1) Lucifer, man in his original state of Selfhood; (2) Molech, the Executioner; (3) Elohim, the Judge of others; (4) Shaddai, the Accuser; (5) Pahad, man's horror at the results of infernal justice; (6) Jehovah, institutor of the laws of conduct; and (7) Jesus, the Saviour.

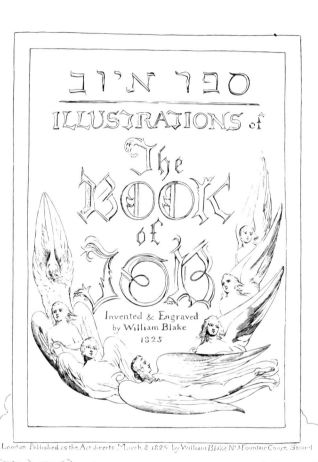

ספר איוב

ILLUSTRATIONS of

The BOOK of JOB

Invented & Engraved
by William Blake
1825

London Published as the Act directs March 8 1825 by William Blake N 3 Fountain Court Strand

ILLUSTRATION I

Thus did Job continually

Job was "the greatest of all the men of the east" (Job i : 3). He was enormously wealthy and consequently enormously powerful. Whenever he appeared in public he created a sensation; in the council, the princes and nobles were silent while they drank in his speeches; and his was the last word. After his ruin, he recalled bitterly this time of his "glory" (Job xxix : 7–25).

His private life was strict. He had risen to his high estate by conscientiousness, hard work, justice, and sobriety. He denied himself all unnecessary pleasures—he had not earned his wealth by dissipation; yet he prided himself on his extensive charities (Job xxix : 12–16; xxxi : 16–22). He had married a wife who adored him and had raised a fine family of seven sons and three daughters.

But above all, Job was pious. He ran his life according to the books of Law. His reward was his wealth, which he believed he had obtained through the favor of his God, who pronounced him "perfect." Consequently he could not help secretly thinking very well of himself.

In the illustration, Job and his family are still in the pastoral state of Innocence. They are shown at their evening prayers. The moment is sacred; therefore all the family's musical instruments are silenced, beginning with Job's own harp and his wife's lute, although the two youngest boys have clung to their pipe and lyre. These instruments are those of spontaneous praise; but Job's prayers are being read from books written by others, while the children kneel humbly.

Job basically is a good man, although he has never recognized the true God. Therefore on his right is his spiritual wealth, a Gothic church, and on his left his material wealth, the flocks and barns. But the sun is setting.

Job's errors are these: he fears God instead of loving him as a friend; he "eschews evil," thus condemning half of life; and he relies on the Letter that Killeth, and thus has closed himself to Spiritual Discernment. Deepest of all is his secret Pride, which must be humbled.

> *Cycle:* First
> *State:* Innocence
> *Eye:* Lucifer
> *Contrary:* Illustration XXI

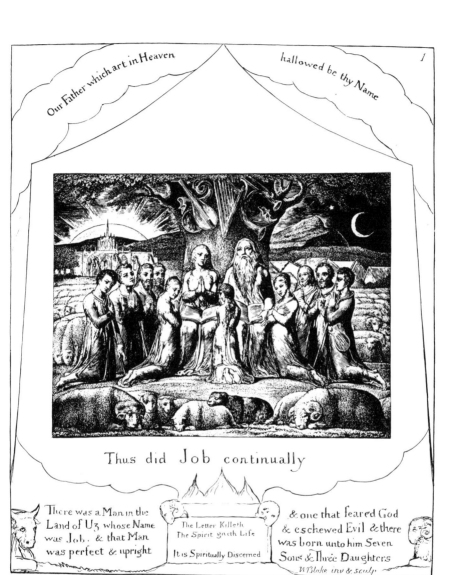

Our Father which art in Heaven

hallowed be thy Name

1

Thus did Job continually

There was a Man in the
Land of Uz whose Name
was Job. & that Man
was perfect & upright

The Letter Killeth
The Spirit giveth Life

It is Spiritually Discerned

& one that feared God
& eschewed Evil &there
was born unto him Seven
Sons & Three Daughters

W Blake inv & sculp

London. Published as the Act directs. March 8:1828. by Will Blake N. Fountain Court Strand.

Proof

ILLUSTRATION II

When the Almighty was yet with me, When my Children were about me

Job's inner life is now opened for us. His God is Job's own ideal, and therefore bears Job's likeness. This God reigns supreme with the book of Law open in his lap. Being Job's own ideal, he can claim that Job is "perfect."

But Job is too conscientious to accept this claim complacently and uncritically. Law implies judgment, and this judgment by Job's God raises a question. At once, Satan the Accuser appears before the Lord. Job himself (for this takes place within his own brain, as indicated by the cloud-barriers, which separate worlds) is questioning his own piety: may it not be merely gratitude for his material prosperity? Surely he has eschewed evil, but real virtue is positive, not negative. His pharisaic pride in his own perfection has admitted into his heaven the Accuser, who is casting doubt on that perfection: "Doth Job fear God for nought?" (Job i:9).

The two dim faces beneath the arms of Satan are the shadowy error of Job and his wife. Until that error is given definite form, it cannot be recognized and cast out.

To answer Satan, angels cast before the throne the scrolls of Job's spontaneous good deeds (only one angel has a book, and that is partly closed); but the Almighty has no scroll: he does not consider such trifles. Yet on earth, angels minister to Job with scrolls of song, although Job himself holds upright the book of Law on his left knee. His wife and all but one of their children also hold books, for Job has tried to bring up his children properly. He knows the dangers that threaten the children of the rich: "They spend their days in wealth, and in a moment go down to the grave. Therefore they say unto God, Depart from us; for we desire not the knowledge of thy ways" (Job xxi:13–14). Job knows that his own children feast every night; consequently in the morning he sacrifices for them: "It may be that my sons have sinned, and cursed God in their hearts" (Job i:4–5). But he does not want to know definitely how they are really acting.

Therefore he turns his back on his eldest son, who already has abandoned his book for a scroll. He sits with his mistress (none of the sons are married) and their baby. He is living his life according to his own instincts. This is the natural reaction of children against the perfection of a stern father.

The margins develop the idea of the illustration. Below are Job and his wife, still in the pastoral state of Innocence. But in the living Gothic decorations are the peacock of pride and the parrot of vain repetitions. Angels weep over the pillars of cloud and flame that led the Israelites through the wilderness to Mount Sinai, where the Ten Commandments were revealed. After Satan's title is written in Hebrew his identification as "King Jehovah."

Cycle: First
State: Innocence
Eye: Lucifer
Contrary: Illustration XVI

14

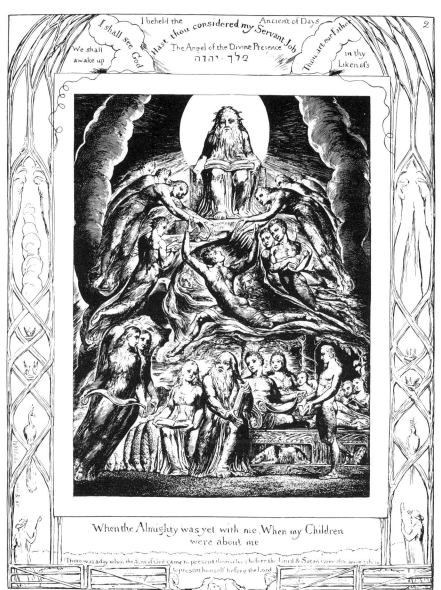

I beheld the Ancient of Days

I shall see God

We shall awake up

Hast thou considered my Servant Job

The Angel of the Divine Presence
מלך · יהוה

Thou art our Father

in thy Likeness

When the Almighty was yet with me, When my Children
were about me

There was a day when the Sons of God came to present themselves before the Lord & Satan came also among them
to present himself before the Lord

London Published as the Act directs March 8: 1825 by Will. Blake N 3 Fountain Court Strand

Proof

ILLUSTRATION III

Thy Sons & thy Daughters were eating & drinking Wine in their eldest Brothers house & behold there came a great wind from the Wilderness & smote upon the four faces of the house & it fell upon the young Men & they are Dead

The dissipation of the children can be ignored only so far. Job learns that his six younger sons have followed their eldest brother's example; they have all taken mistresses. Job's wrath explodes. Satan the Accuser, born in Job's own brain, destroys his sons and their women, demolishing them and their (classical) palace of delights with lightnings and black (hellish) fire from Job's heaven.

The eldest son tries to rise (on his left foot) and save at least his illegitimate boy from the shame of his birth, but all material means fail him. One brother falls in the position of the "crucifixion upside down," in which the lower desires rule both heart and head; beneath him is a heap of massy plate, which includes a wine goblet, the wealth that has caused his degeneration. Another brother appears effeminate. Their seven concubines are also destroyed. One of them lies with her feet on a timbrel and a lyre beneath her left hand: the music she had degraded to secular pleasure.

The death of the sons is not to be understood according to the letter: it is a spiritual act. After the family quarrel, the sons are as dead to their father. The three daughters do not appear here; it is not recorded that they were killed, and they reappear later. So do the sons, in Illustration XXI.

In the margins the flames are repeated; two scorpions raise their stings; and coils of the great serpent, who is the religion Materialism, now begin to be visible.

Cycle: First
State: Experience
Eye: Molech
Contrary: Illustration XX

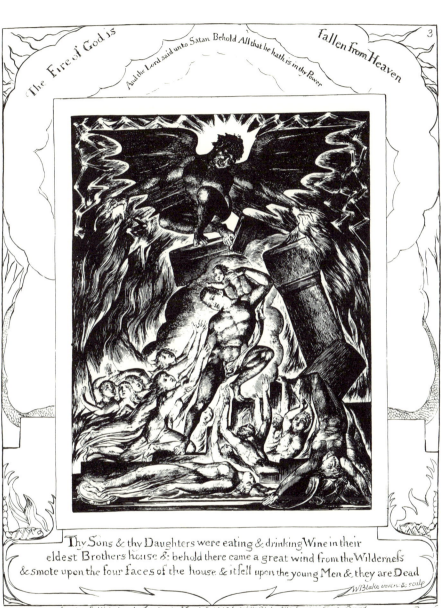

The Fire of God is

And the Lord said unto Satan Behold All that he hath is in thy Power

Fallen from Heaven

Thy Sons & thy Daughters were eating & drinking Wine in their
eldest Brothers house & behold there came a great wind from the Wilderness
& smote upon the four faces of the house & it fell upon the young Men & they are Dead

W Blake inven & sculp

London, Published as the Act directs March 8, 1825 by Will. Blake N 3 Fountain Court Strand

Proof

ILLUSTRATION IV

And I only am escaped alone to tell thee.

Two messengers arrive left foot first, for the disasters they announce are material; but the third messenger, just visible on the horizon, is coming right foot first, with the tidings of the death of Job's sons. Job and his wife sit beneath the two heavy stone crosses, which will not be broken until Illustration XIX. Above them is a tree with scant foliage and no fruit. The Gothic church appears for the last time.

The news strikes Job like a thunderbolt, which is seen in the margin. Satan enters even deeper into Job's soul. With his sword in his left (material) hand, he surmounts the globe and moves inward. On the upper corners of the illustration lie the dead forms of angels—the innocent joys or spiritual blessings—which later will revive.

Cycle: First
State: Experience
Eye: Molech
Contrary: Illustration XIX

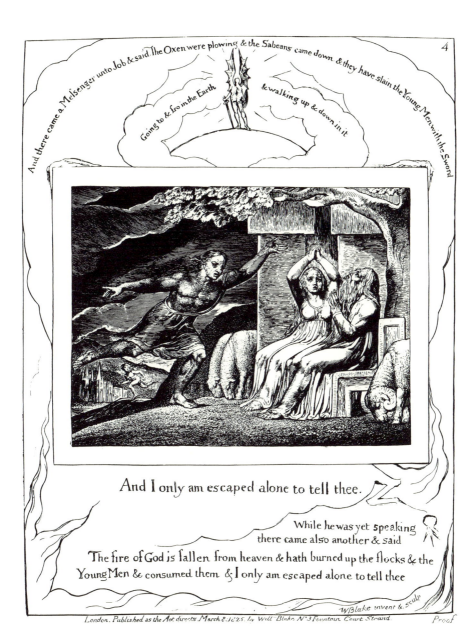

And there came a Messenger unto Job & said. The Oxen were plowing & the Sabeans came down. & they have slain the Young Men with the Sword

Going to & fro in the Earth

& walking up & down in it

And I only am escaped alone to tell thee.

While he was yet speaking
there came also another & said

The fire of God is fallen from heaven & hath burned up the flocks & the
Young Men & consumed them & I only am escaped alone to tell thee

WBlake invent & sculp

London. Published as the Act directs March 8. 1825. by Will Blake N° 3 Fountain Court Strand

Proof

ILLUSTRATION V

Then went Satan forth from the presence of the Lord

This scene is not in the Bible, but is one of the finest in Blake's system. Job is sharing his last loaf with a blind beggar. He does it for the same reason that he has done everything else: because it is the correct thing to do, not because he naturally wishes to do it, as a man would share his last meal with a starving friend. Such charity as Job's can be given—and taken—only with the left hand, for true sympathy is absent. Job can make the gesture of charity to a beggar whose sins he cares nothing about, although he treated his own children harshly. Even so, this charity is a spiritual act (his right foot protrudes from beneath his robe), as Job wants to do the best thing, even if he cannot do it in the proper spirit. He is right, though for the wrong reason. Therefore angels still minister to him.

Therefore also Job's God keeps his seat by clinging to his book of Law, though, with a dimmed and sinking halo, he is dragged down on the material side. The scroll, which represents the better side of life that he has ignored, appears, dangling and unnoticed, in his left hand.

The fires that Satan concentrates on the head of Job are the fires of guilt; the appalled angels shrink from them.

The Gothic church has disappeared, for Job is now in error. The druid architecture has replaced it, symbolic of the primal, brutal religion of Moral Law which sacrifices others but not the Self.

The sympathy of Job's wife is in direct contradiction to the Biblical account. There she urged her husband to curse God and die; here she supports her husband with perfect confidence and love.

The margins are filled with flames and briars, and below is the serpent, at last fully revealed, though not to Job.

Cycle: First
State: Experience
Eye: Elohim
Contrary: Illustration XIX

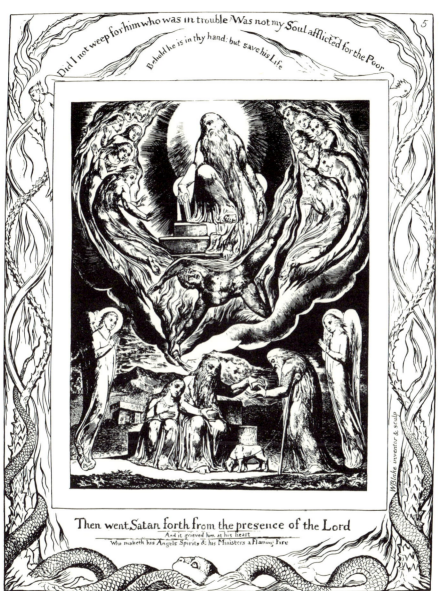

5

Did I not weep for him who was in trouble Was not my Soul afflicted for the Poor

Behold he is in thy hand: but save his Life

W Blake inventor & sculp

Then went Satan forth from the presence of the Lord

And it grieved him at his heart

Who maketh his Angels Spirits & his Ministers a Flaming Fire

London, Published as the Act directs March 8 1825, by Will*m Blake N*3 Fountain Court Strand

Proof

ILLUSTRATION VI

And smote Job with sore Boils from the sole of his foot to the crown of his head

Satan's second assault on Job strikes at him personally. Boils were traditionally the signs of a venereal disease. For Blake, however, the boils signify a spiritual disease, involving Job's sensorial and emotional life and closing him from Eternity.

Boils are "the terrible smitings of Luvah," the regent of love (*Jerusalem* 29 : 64). Satan the Accuser, his genitals scaled over, infects Job with the feeling of guilt over sex: "The disease of Shame covers me from head to feet. I have no hope. Every boil upon my body is a separate & deadly Sin. Doubt first assail'd me, then Shame took possession of me" (*Jerusalem* 21:3–5).

The death of four of Job's senses—sight, hearing, taste, and smell—is indicated by the four arrows beneath Satan's right hand. The fifth, touch, which in its highest form is sex, man's easiest way into Eternity, is now corrupted. The sun is disappearing, not to be seen again until the last plate.

Job's wife is now separated from her husband; nevertheless she still ministers to his lowest needs (his feet).

In the margin below is the broken sheephook of Innocence, with symbols from the despairing last chapter of Ecclesiastes (xii : 5): "the grasshopper [destroyer of crops] shall be a burden, and desire shall fail." The pitcher is broken at the fountain, which now is choked with rubbish and identifiable only by the frog still dwelling there. Bat-winged angels lower poisonous spiders, and there are thistles in one corner.

Cycle: First
State: Experience
Eye: Elohim
Contrary: Illustration XIV

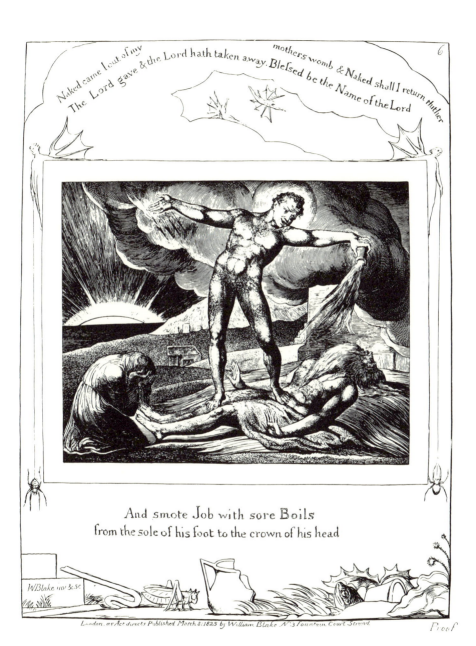

Naked came I out of my mothers womb, & Naked shall I return thither
The Lord gave & the Lord hath taken away. Blefsed be the Name of the Lord

And smote Job with sore Boils
from the sole of his foot to the crown of his head

W Blake inv & sc

London, as Act directs Published March 8: 1825 by William Blake N° 3 Fountain Court Strand

Proof

ILLUSTRATION VII

And when they lifted up their eyes afar off & knew him not they lifted up their voice & wept, and they rent every Man his mantle & sprinkled dust upon their heads towards heaven

Job's three friends arrive, left foot first, to console him. But their sympathies are such that the term "Job's comforters" has become an ironic commonplace: "Corporeal Friends are Spiritual Enemies" (*Milton* 4:26). Indeed, their arguments constitute Job's third trial. The sun has set.

In the margin stand Job and his wife, beneath sterile trees. They are still shepherds of Innocence, enduring their sorrows of Experience with resignation.

Cycle: First
State: Experience
Eye: Shaddai
Contrary: Illustration XIX

What! shall we recieve Good
at the hand of God & shall we not also
recieve Evil

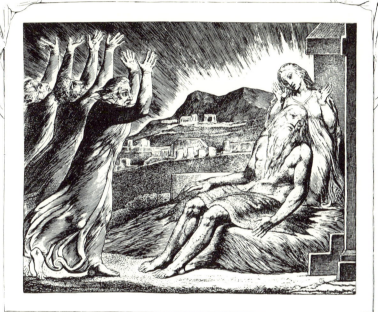

And when they lifted up their eyes afar off & knew him not
they lifted up their voice & wept. & they rent every Man his
mantle & sprinkled dust upon their heads towards heaven

Ye have heard of the Patience of Job and have seen the end of the Lord

WBlake inven & sculpt.

London, Published as the Act directs March 8. 1825 by William Blake N3 Fountain Court Strand

Proof

ILLUSTRATION VIII

Let the Day perish wherein I was Born

The seven days of silent mourning are over (Job ii : 13); a new cycle begins. At last Job reacts against his woes. His proverbial patience is at an end; no longer does he endure his misfortunes passively. His wrath breaks forth; it is a spiritual turning point, that of Revolution. He sits beneath the stone cross no longer; it has gone from him forever. Now he can begin to question his situation, question the justice of his disasters, and by questioning eventually find the true God. Meanwhile the cross stands above his friends, who are still in error.

At first Job's wrath is blind, but it brings him to the realization that his great wealth has never brought him the happiness of security: "For the thing which I greatly feared is come upon me, and that which I was afraid of is come unto me. I was not in safety, neither had I rest, neither was I quiet; yet trouble came" (Job iii : 25–26). He is questioning the former purpose of his whole life.

In the margins, the clouds distill raindrops upon toadstools, briars, and thistles.

Cycle: Second
State: Revolution
Eye: Shaddai
Contrary: Illustration XVIII

26

Lo let that night be solitary
& let no joyful voice come therein.

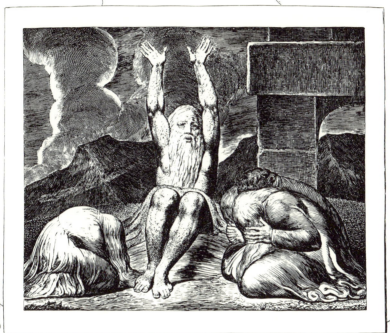

Let the Day perish wherein I was Born

And they sat down with him upon the ground seven days & seven
nights & none spake a word unto him for they saw that his grief
was very great

London Published as the Act directs March 8. 1825 by Will Blake N 3 Fountain Court Strand

Proof

ILLUSTRATION IX

Then a Spirit passed before my face | the hair of my flesh stood up

In this illustration are condensed the long arguments of Job's friends, who insist that since God is just, Job's calamities must be punishment for his sins.

Eliphaz (also seen above, reclining) describes this God (Pahad), who is a nightmare. His arms are concealed: he is obliged to reward or punish according to the deserts of mankind.

In the margins is the "forest of the night," a traditional symbol for the sterile growth of errors, whose false theories block the path and hide the heavens. These trees are to be blown down by the Whirlwind (Illustration XIII).

> *Cycle:* Second
> *State:* The Dark Night
> *Eye:* Pahad
> *Contrary:* Illustration XVII

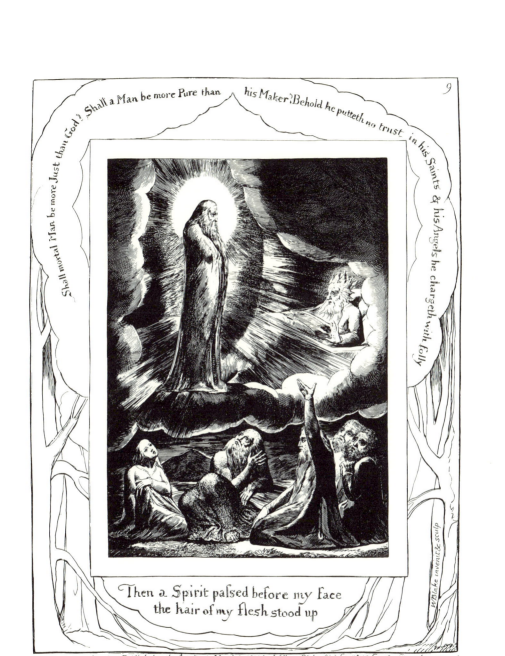

Shall mortal Man be more Just than God? Shall a Man be more Pure than his Maker? Behold he putteth no trust in his Saints & his Angels he chargeth with folly

Then a Spirit passed before my face
the hair of my flesh stood up

WBlake invent& sculp

London, Published as the Act directs March 8. 1825 by William Blake N 3 Fountain Court, Strand

Proof

ILLUSTRATION X

The Just Upright Man is laughed to scorn

Job's first error was the admission of Satan the Accuser into his mind. Now that error appears in the outer world: his friends condemn him even as he had condemned his children. The friends separate themselves from him when they should "enter his bosom," for they think to make themselves more holy by treading him down. Even his wife doubts him momentarily; the cross stands above her now. The friends have almost convinced her: in terrified anguish she looks to her husband for his answer.

But this trial benefits Job. Completely guiltless, as far as he knows, he appeals to his God for justification. The result, as the next illustration shows, is a terrible revelation.

Job's expostulations, his faith in his God, his belief in his innocence, and his appeal for pity are relegated to the margins. At the upper corners, two angels struggle upward, in spite of chains that drag them down. In the lower margin, the cuckoo of slander, the owl of false wisdom clutching a victim, and the adder of hate mock the scrolls of true inspiration. This is Blake's comment on the critics who attacked his work so blindly and unmercifully.

Cycle: Second
State: The Dark Night
Eye: Pahad
Contrary: Illustration XVIII

But he knoweth the way that I take
when he hath tried me I shall come forth like gold

Have pity upon me: Have pity upon me: O ye my friends
for the hand of God hath touched me

Though he slay me yet will I trust in him

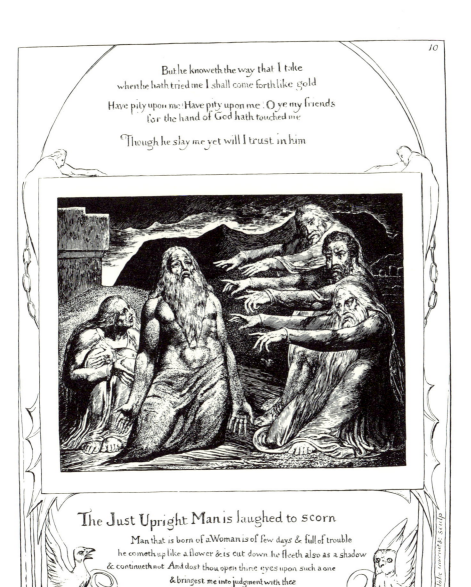

The Just Upright Man is laughed to scorn

Man that is born of a Woman is of few days & full of trouble
he cometh up like a flower & is cut down he fleeth also as a shadow
& continueth not And dost thou open thine eyes upon such a one
& bringest me into judgment with thee

London Published as the Act directs March 8: 1825. by William Blake N3 Fountain Court Strand

W Blake invent & sculp

Proof

ILLUSTRATION XI

With Dreams upon my bed thou scarest me & affrightest me with Visions

Job's God is identical with the God of Eliphaz. He is the same God of untempered Justice. He points with his right hand to the stone tables of the Law, from which start the lightnings of damnation, and with his left hand to the Hell below to which his Law condemns Job. Devils reach up from the black flames to drag Job down by his feet and loins.

But Job sees for the first time the cloven hoof of this God's left foot; for the God of Justice is only Satan, masquerading as an angel of light. He is the Accuser, who knows that no man is so pure as to be perfect. Every man judged by this God—the God of this world only—is condemned. And this God is entwined with the serpent of Materialism.

This is Blake's most insistent doctrine. The true God is not the evil and temporary God of Justice, but Jesus, who forgives all sins and requires no penalty. The sinner is punished already in the very act of his sin; what profit, then, to inflict mechanically some preordained chastisement? Understanding which is forgiveness is the true Saviour.

This is the nadir of Job's life and the turning point. Here only, by bitter Experience, literally "bought with the price of all that a man hath" (*The Four Zoas* ii : 398), he has seen and recognized that his supposed God is his Devil.

The progress of Job's thoughts is shown in the marginal texts, reading from top to bottom. They begin with his physical sufferings, come to a climax in the recognition of Satan, then continue below the illustration with a new and crucial revelation: there must be a better God.

Job had always supposed that death was the end of all, although once he had wondered momentarily, "If a man die, shall he live again?" (Job xiv : 14). That hope has now become a conviction: "For I know that my redeemer liveth, and that he shall stand at the latter day upon the earth: And though after my skin worms destroy this body, yet in my flesh shall I see God: Whom I shall see for myself, and mine eyes shall behold, and not another; though my reins be consumed within me" (Job xix : 25–27). To emphasize his belief that the spiritual body survives the physical, Blake altered part of this text to read: "& after my skin destroy thou This body yet in my flesh shall I see God | whom I shall see for myself | and mine eyes shall behold & not Another, tho consumed be my wrought Image." The last clause—Blake's own version—is a reasonable translation of the text, as the Biblical term "reins" signifies the affections and can stand by synecdoche for the entire physiology.

Cycle: Second
State: The Dark Night
Eye: Jehovah
Contrary: Illustration XIII

My bones are pierced in me in the night season & my sinews take no rest

My skin is black upon me & my bones are burned with heat

The triumphing of the wicked
is short, the joy of the hypocrite is
but for a moment
Satan himself is transformed into an Angel of Light & his Ministers into Ministers of Righteousnefs

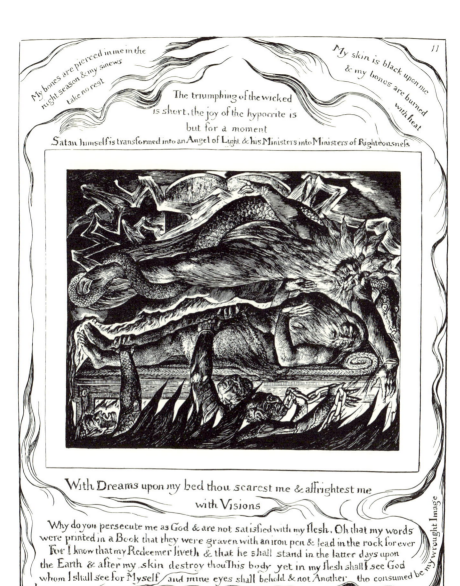

With Dreams upon my bed thou scarest me & affrightest me
with Visions

Why do you persecute me as God & are not satisfied with my flesh. Oh that my words
were printed in a Book that they were graven with an iron pen & lead in the rock for ever
For I know that my Redeemer liveth & that he shall stand in the latter days upon
the Earth & after my skin destroy thouThis body yet in my flesh shall I see God
whom I shall see for Myself and mine eyes shall behold & not Another: tho consumed be my wrought Image

Who opposeth & exalteth himself above all that is called God or is Worshipped

W Blake invent & sculp

London. Published as the Act directs March 8. 1825 by Will Blake N.º 3 Fountain Court Strand

Proof

ILLUSTRATION XII

I am Young & ye are very Old wherefore I was afraid

Both Job and his friends are silenced; neither has convinced the other and they have no more to say.

Young Elihu then enters the colloquium. He is moved to wrath against Job for justifying himself instead of God, and even more against the friends for condemning Job without answering him. According to his posture, his arguments are basically those drawn from the astronomical universe: his left hand points to the stars, which are also scattered through the margins, and his left foot is advanced. He avers that God and his universe are too great to be comprehended, yet God has particular care for man. These are commonplaces; nevertheless, certain of Elihu's phrases plunge Job into deep thought.

These phrases that are so significant to Job appear in the margins. Job has complained that his God has remained silent; Elihu says that "God speaketh once yea twice & Man percieveth it not." Had Job been missing the divine instruction? "In a Dream in a Vision of the Night . . . he openeth the ears of Men & sealeth their instruction." Had Job not understood the meaning of his nightmare? "That he may withdraw Man from his purpose & hide Pride from Man." Had Job had the wrong purpose, and had he not been proud? "Then he is gracious unto him & saith Deliver him from going down to the Pit. I have found a Ransom." Could there be a Redeemer?

In the lower margin is Job's sleeping Humanity, with streams of soaring angels who urge him to wake. His hand is upon a scroll, and close above him is the command "Look upon the heavens & behold the clouds which are higher than thou." These clouds presage the Whirlwind, for Elihu speaks of a coming storm. Hidden under Job's head is a text which suggests that the true God is not the God of Morality at all but one who is unconcerned about the petty faults or virtues of his children: "If thou sinnest what doest thou against him or if thou be righteous what givest thou unto him?"

Cycle: Second
State: The Dark Night
Eye: Jehovah
Contrary: Illustration XV

For God speaketh once yea twice
& Man perceiveth it not

In a Dream in a Vision of the Night
in deep Slumberings upon the bed
Then he openeth the ears of Men & sealeth their instruction

That he may withdraw Man from his purpose
& hide Pride from Man
If there be with him an Interpreter One among a Thousand
& saith Deliver him from going down to the Pit
then he is gracious unto him
I have found a Ransom

For his eyes are upon
the ways of Man & he observeth
all his goings

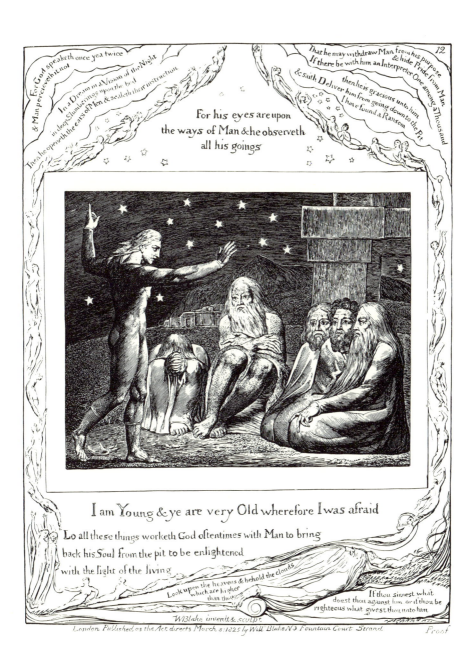

I am Young & ye are very Old wherefore I was afraid

Lo all these things worketh God oftentimes with Man to bring

back his Soul from the pit to be enlightened

with the light of the living

Look upon the heavens & behold the clouds
which are higher
than thou

If thou sinnest what
doest thou against him or if thou be
righteous what givest thou unto him

W Blake invenit & sculpt

London Published as the Act directs March 8: 1825 by Will Blake N 3 Fountain Court Strand Proof

ILLUSTRATION XIII

Then the Lord answered Job out of the Whirlwind

At last, in the Whirlwind of the mystical ecstasy, the true God appears. He is Jesus, the Divine Imagination, and the Forgiveness of Sins: the only God whom Blake recognized. He is in the cruciform position and his right foot is forward. He descends below the cloud-barriers which normally separate the worlds. Job and his wife face God with serene joy. The power of the wind raises Job's hair in an agreeable thrill, to be contrasted with the horror-struck erected hair of Eliphaz (Illustration IX). Meanwhile, the friends cannot see God because the blast blows them flat, like the Forest of Error in the margin below.

The Lord's response to Job is not a reasoned reply to his plaints, but is instead a typically mystical and fundamentally ineffable vision of God's divine power in the greatness, the glory, and the harmony of his creation, the universe. Job's pride is crushed at last; his life is made straight; his faith is confirmed.

Thirteen is the number of Death (as also in Blake's *The Gates of Paradise*); it is therefore necessarily the number of the New Birth.

The upper margin continues the circular motion of the Whirlwind. The figures are the six Eyes in their rotation; inevitably they have reached the seventh, who is Jesus (within the illustration), although the Lord's likeness is that of Job. Behind Job's head (in the outer margin) is the suggestion of an eighth Eye: this is Job's own Individuality, "an Eighth Image Divine, tho' darken'd and tho' walking as one walks in sleep, and the Seven comforted him and supported him" (*Milton* 15 : 5–7).

Cycle: Second
State: The New Life
Eye: Jesus
Contrary: Illustration XI

36

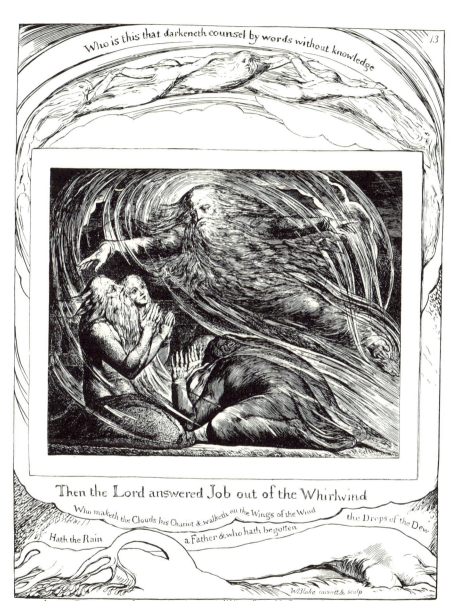

Then the Lord answered Job out of the Whirlwind

Who is this that darkeneth counsel by words without knowledge

13

Who maketh the Clouds his Chariot & walketh on the Wings of the Wind

the Drops of the Dew

Hath the Rain

a Father & who hath begotten

WBlake invent & sculp

London Published as the Act directs March 8. 1825 by William Blake N 3 Fountain Court Strand

Proof

ILLUSTRATION XIV

When the morning Stars sang together, & all the Sons of God shouted for joy

The mystical ecstasy is a state of knowledge as well as emotion, but the knowledge is usually so profound as to be incommunicable afterward. Blake, however, possessed two arts with which to capture and define the wisdom obtained from such experience. The vision of the universe, which appears in this illustration, is an aspect of Job's experience with the Whirlwind.

This universe is the fourfold soul of man: the flesh, the brain, the heart, and the imagination. Lowest is the world of flesh, wherein Job sits with his wife and friends; they are shut in by the thickest of the cloud-barriers. Above them to the left is the Greek god Apollo, who represents the intellect. The radiant sun god, drawn by the horses of instruction, endeavors perpetually to push back the clouds enclosing his world, thus enlarging it. Balancing him on the right is the moon goddess Diana, the heart. Her purity guides the dragons of passion in the night of Beulah (marriage). Highest of all is the realm of the imagination, enclosed by the thinnest of the cloud-barriers. It is separated from the others by a small space, which expands into other empty spaces, suggesting that there are worlds in the human soul as yet unknown.

Binding all together is the central figure of God, who is the Divine Imagination, as always in Blake's writings. He is in the cruciform position of self-sacrifice. His arms protect the brain and the heart, and only through him can the realm of spirit be entered.

In his poems, Blake named these realms "the Four Zoas": Tharmas, the flesh; Urizen, the intellect; Luvah, the emotions; and Los, the creative spirit.

In the side margins are the six days of the creation, which are but a framework for this, the seventh and last creation, the Sabbath and Millennium, the spiritual rebirth of man. The lower margin continues the cloud-barrier of the realm of the flesh with the body of the Leviathan of Nature, which is in the Sea of Time and Space. Below him is the worm of death, coiled round a shrouded corpse. In the upper corners are the constellations of the Pleiades and Orion (Job xxxviii: 31).

> *Cycle:* Second
> *State:* The New Life
> *Eye:* Jesus
> *Contrary:* Illustration VI

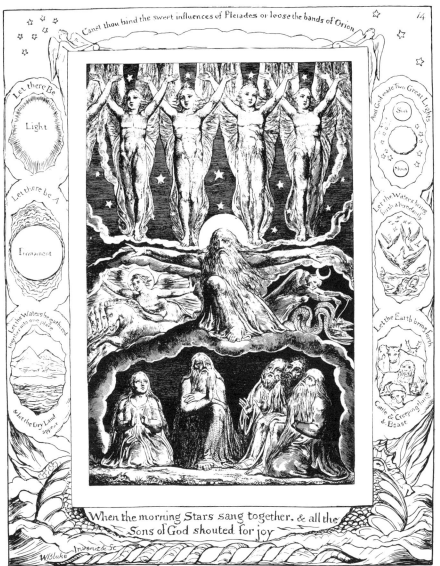

Canst thou bind the sweet influences of Pleiades or loose the bands of Orion

Let there Be

Light

Let there be A

Firmament

Let the Waters be gathered
together into one place

& let the Dry Land
appear

And God made Two Great Lights

Sun

Moon

Let the Waters bring
forth abundantly

Let the Earth bring forth

Cattle & Creeping thing
& Beast

When the morning Stars sang together, & all the
Sons of God shouted for joy

W Blake Inven & Sc

London. Published as the Act directs March 8. 1825 by Will Blake N 3 Fountain Court Strand

Proof

ILLUSTRATION XV

Behold now Behemoth which I made with thee

Job's illumination continues.

God explains the mystery of the incessant warfare in the human world. He reaches down through the cloud-barrier with his left hand, like Urizen in the famous frontispiece to *Europe;* the stars further associate the two, as Urizen is prince of the starry realm. God indicates Behemoth and Leviathan, with whose description he ends his speech to Job (Job xl : 15–24; xli : 1–34).

These two creatures exist in man himself: "Behold now Behemoth which I made with thee." The cloud-barrier of Job's world includes the separate sphere in which they exist; it is a picture of the subconscious, the unredeemed portion of the psyche, which the bulrushes identify as Egypt—the unredeemed portion of mankind. These are terrible forces within man, against which he seems helpless: "the War by Sea enormous & the War by Land astounding, erecting pillars in the deepest Hell to reach the heavenly arches" (*Jerusalem* 91 : 39–42). They function as a means of God's providence. Behemoth is "the chief of the ways of God": warfare of the spirit is one of the chief joys of Eternity, though when materialized on earth it is rendered deadly (*Milton* 34 : 50–52; 35 : 2–3). Leviathan is "King over all the Children of Pride"—that is, over all unredeemed mankind. His name means "coiled," and therefore he is depicted as having a huge spiral, representing the everlasting repetitions in the round of nature.

At the upper corners, recording angels write the laws of the universe; at the lower corners are the eagles which Urizen sends forth in his work of creation (*The Four Zoas* ii : 150). Below are the emptied shells of the mortal bodies which are grown by man's spirit and then abandoned on the margin of the Sea of Time and Space.

This illustration begins the last and third cycle, in which the errors of the first two cycles are corrected.

Cycle: Third
State: The New Life
Eye: Jehovah
Contrary: Illustration XII

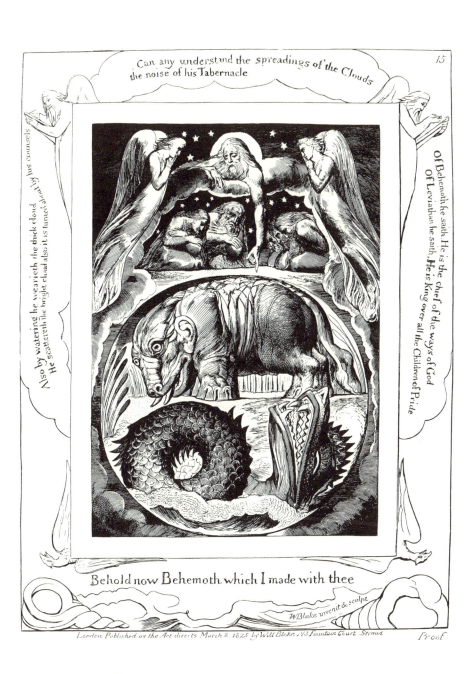

Can any understand the spreadings of the Clouds
the noise of his Tabernacle

Also by watering he wearieth the thick cloud
He scattereth the bright cloud also it is turned about by his counsels

Of Behemoth he saith. He is the chief of the ways of God
Of Leviathan he saith. He is King over all the Children of Pride

Behold now Behemoth which I made with thee

W Blake invenit & sculpt

London Publishd as the Act directs March 8. 1825 by Will Blake, N.³ Fountain Court, Strand

Proof

ILLUSTRATION XVI

Thou hast fulfilled the Judgment of the Wicked

"Whenever any Individual Rejects Error & Embraces Truth, a Last Judgment passes upon that Individual" (*A Vision of the Last Judgment*, Keynes, p. 613). Satan the Accuser is cast out of Job's heaven, and with him fall the errors of Job and his wife, now given full form. (In Illustration II they were only dim faces beneath Satan's arms.) They fall into the flames of annihilation—not of everlasting torture, for such a hell Blake did not admit; Error recognized is Error destroyed.

God is again seated firmly on his throne; he still holds his book, for Law is essential to life; but his halo now contains figures of love and pity, whose attitudes are repeated by the two attending angels.

The fall of Satan has opened a gulf between Job and his friends.

In the margins, flames consume the material creation, as in Blake's *The Marriage of Heaven and Hell*, Plate 14.

> *Cycle:* Third
> *State:* The New Life
> *Eye:* Jesus
> *Contrary:* Illustration II

Hell is naked before him & Destruction has no covering

Canst thou find out the Almighty to perfection

Canst thou by searching find out God

The Accuser of our Brethren is Cast down
which accused them before our God day & night

It is higher than Heaven what canst thou do

It is deeper than Hell what canst thou know

The Prince of this World shall be cast out

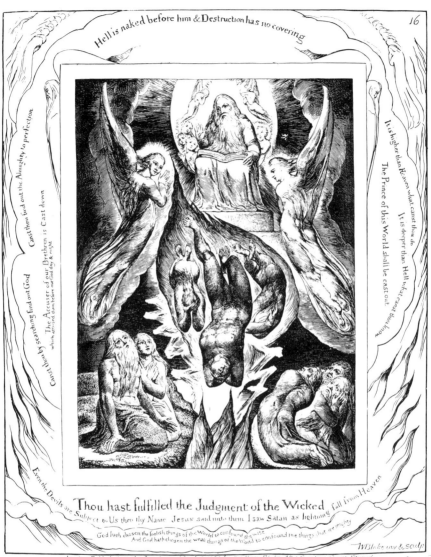

Thou hast fulfilled the Judgment of the Wicked fall from Heaven

Even the Devils are Subject to Us thro thy Name Jesus said unto them I saw Satan as lightning

God hath chosen the foolish things of the World to confound the wise
And God hath chosen the weak things of the World to confound the things that are mighty

WBlake inv & sculp

London, Published as the Act directs March 8 1825 by William Blake N 3 Fountain Court Strand

Proof

ILLUSTRATION XVII

I have heard thee with the hearing of the Ear but now my Eye seeth thee

In the Whirlwind God descended below the clouds into this world; now he has returned to heaven and brought man with him. This is clearly indicated by the clouds on which the Deity stands.

The last four lines of Blake's *Auguries of Innocence* (Keynes, p. 434) explain this illustration:

> God Appears & God is Light
> To those poor Souls who dwell in Night,
> But does a Human Form Display
> To those who Dwell in Realms of day.

The friends are still in the night, and the light to them is intolerable; but Job and his wife face God and know him for a comrade, in whose image they were made: "we know that when he shall appear we shall be like him for we shall see him as He Is."

The angel in the margin below is the Comforter, who is the Spirit of Truth. Her texts (all from the Gospel of John) assert the identity of the Son with the Father, who loves all his children equally, unprejudiced by their virtues or vices. Two of the texts are in books; the most important is on a scroll. Scroll and books are now in harmony.

Cycle: Third
State: The New Life
Eye: Pahad
Contrary: Illustration IX

He bringeth down to the Grave & bringeth up

we know that when he shall appear we shall be like him for we shall see him as He Is

When I behold the Heavens the work of thy hands the Moon & Stars which thou hast ordained, then I say, What is Man that thou art mindful of him? & the Son of Man that thou visitest him.

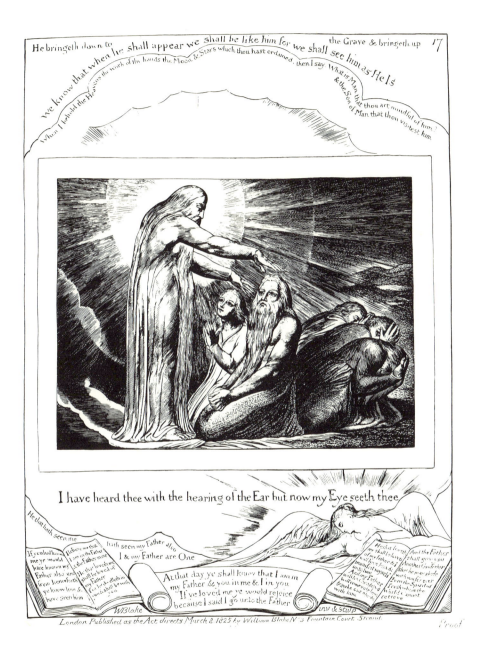

I have heard thee with the hearing of the Ear but now my Eye seeth thee

He that hath seen me

hath seen my Father also
I & my Father are One

If ye had known
me ye would
have known my
Father also and
from henceforth
ye know him &
have seen him

Believe me that
I am in the Father
& the Father in me

He that loveth me
shall be loved of
my Father
for I will be in
him & be with
you

At that day ye shall know that I am in
my Father & you in me & I in you
If ye loved me ye would rejoice
because I said I go unto the Father

He that loveth
me shall be loved
of my father & I
will love him &
will manifest myself
unto him
will come & make
our abode
with him

And the Father
shall give you
Another Comforter
that he may abide
with you for ever
even the Spirit of
truth whom the
world cannot
recieve

W Blake

inv & sculp

London Published as the Act directs March 8 1825 by William Blake N 3 Fountain Court Strand

Proof

ILLUSTRATION XVIII

And my Servant Job shall pray for you

Though the mystical ecstasy is temporary, it affects all the rest of man's life. God has now withdrawn from his complete manifestation as Man to the likeness of a great sun in the heavens. Meanwhile, Job finds that in prayer the great mystical descent, typified by the angels in the margins, is mildly repeated.

Rebuked by the Lord, the friends ask Job to pray for them. He does so; it is the Forgiveness of Sins. Thereupon the Lord accepts Job and releases him from his captivity under Satan the Accuser.

His prayer is one of forgiveness, self-sacrifice (represented by his cruciform attitude), an inward act (since he faces inward). And the flame of his sacrifice pierces the clouds that separate the worlds and reaches to the heart of God. The wheat in the margin signifies that prayer is the Daily Bread of the soul. The Wine, the other aspect of the Eucharist, appears later, in Illustration XX.

In Plato's *Timaeus* Blake could have found the cube representing the earth and the pyramidal flame representing the spirit; he combined the two.

In the lower margin is the text for Forgiveness, in a book, along with the scrolls of Blake's poems, his palette, and his graver: the arts also are forms of prayer.

Cycle: Third
State: The New Life
Eye: Shaddai
Contraries: Illustrations VIII, X

46

Also the Lord accepted Job

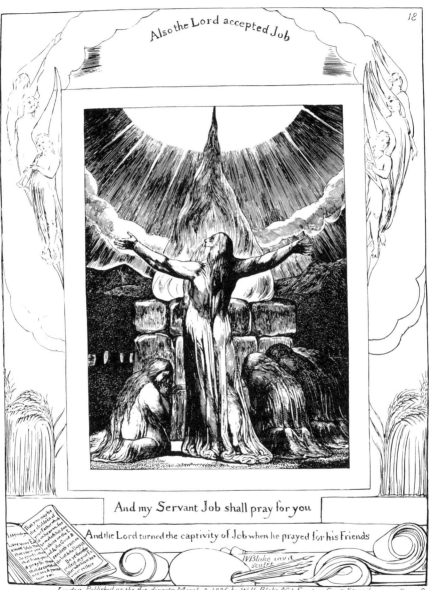

And my Servant Job shall pray for you

And the Lord turned the captivity of Job when he prayed for his Friends

WBlake inv & sculp

London Published as the Act directs March 8 1825 by Will Blake N 3 Fountain Court Strand

Proof

ILLUSTRATION XIX

Every one also gave him a piece of Money

As Job lost virtue by giving to a beggar, so now he gains it by receiving from his friends. This is the true charity springing from personal sympathy, which was missing in Illustration V. One woman even offers Job her gold earring (Job xlii:11).

At last the heavy cross over Job's head is broken. Prosperity is shown by the fruiting fig tree and the standing wheat. Angels crowd round the corners of the design with the palms of victory, for Job has conquered his pride at last; and below are the roses and lilies of material and spiritual beauty: "The thankful reciever bears a plentiful harvest" (51st Proverb of Hell, Keynes, p. 152).

As Joseph Wicksteed points out (*Blake's Vision*, 1924, p. 200), the illustration is a "tender and passionate acknowledgment" of Blake's indebtedness to the Linnells.

> *Cycle:* Third
> *State:* The New Life
> *Eye:* Elohim
> *Contraries:* Illustrations IV, V, VII

The Lord maketh Poor & maketh Rich

He bringeth Low & Lifteth Up

who provideth for the
Raven his Food
When his young ones cry unto God

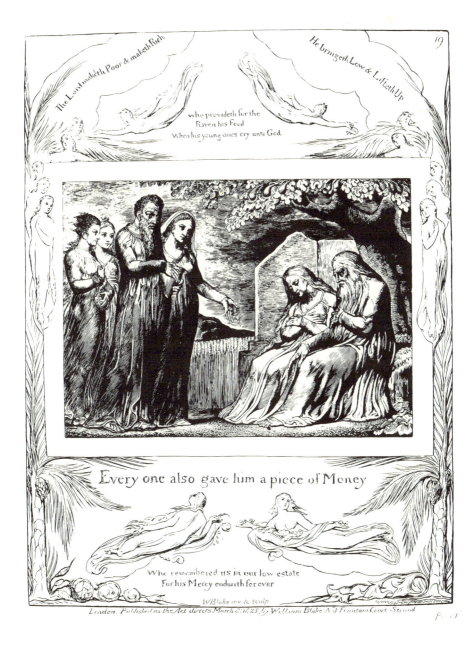

Every one also gave him a piece of Money

Who remembered us in our low estate
For his Mercy endureth for ever

W Blake inv & sculp

London. Published as the Act directs March 8: 1825, by William Blake N 3 Fountain Court, Strand

ILLUSTRATION XX

There were not found Women fair as the Daughters of Job in all the Land & their Father gave them Inheritance among their Brethren

It is not enough to be saved: the redeemed must show the way to others. This is done by means of the arts. Job is relating his experiences to his three daughters—Poetry, Painting, and Music—who had vanished during the period of Job's trials but have now reappeared. (In the first version of this illustration, a water color made for Thomas Butts, the daughters hold the instruments of their arts.) They are enriched by their inheritance of Job's experiences, for the benefit of their spiritual brothers.

Aesthetic creation is a lower form of the mystical ecstasy, the Whirlwind, which is depicted immediately above Job. To his right and left are panels depicting the disasters that befell him. Beneath them, under a serpentine design, are the figures of his wife and himself when in the state of despair.

In his prayer (Illustration XVIII) Job faced inward; now, as he is giving himself for mankind, he faces outward, in the cruciform position of God, who is seen in the panel above him. The two texts in the upper margin, from Psalm cxxxix, state that inspiration comes from God and is to be found everywhere.

The floor consists of a great circle tessellated with many smaller interlacing circles. This represents the communion of the heaven of art; the smaller circles represent individuals entering each other's bosoms (the inscribed portions being significantly four-sided), all of them being contained in the one great circle, who is the One Man, Jesus himself.

Art is the sacrificial wine of the Eucharist. In the margins are fruiting grapevines and instruments of music. The little angels who embrace on the corners repeat this communion of delight.

Cycle: Third
State: The New Life
Eye: Molech
Contrary: Illustration III

How precious are thy thoughts
unto me O God
how great is the sum of them

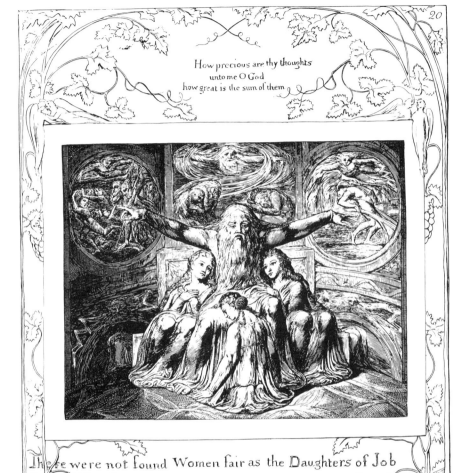

There were not found Women fair as the Daughters of Job

in all the Land & their Father gave them Inheritance

among their Brethren

If I ascend up into Heaven thou art there
If I make my bed in Hell behold Thou
art there

W Blake invent &c

London. Published as the Act directs March 8 1825 by William Blake N 3 Fountain Court Strand

Proof

ILLUSTRATION XXI

So the Lord blessed the latter end of Job more than the beginning

And here the story of Job ends. The long night is over and the sun rises. In the west is the moon, attended by two stars, one of which is the morning star, Lucifer. Job's manhood, purged of all error, is now complete, and his wealth is doubled (Job xlii : 10). The whole family is reunited in harmony; the sons and daughters are restored. No longer do they kneel, no longer are they silent. They and their parents make a joyful noise unto the Lord with the musical instruments formerly hung on the tree. The books of Law have disappeared. The three arts join in the celebration: the daughter on the right plays a lyre (music), and the girl in front sings from a scroll (poetry); the slender book held by the third daughter represents painting.

The Justice of the Old Testament and the Mercy of the New are united: "they sing the song of Moses the servant of God, and the song of the Lamb, saying, Great and marvellous are thy works, Lord God Almighty; just and true are thy ways, thou King of saints" (Revelation xv : 3).

> *Cycle:* Third
> *State:* The New Life
> *Eye:* Lucifer
> *Contrary:* Illustration I

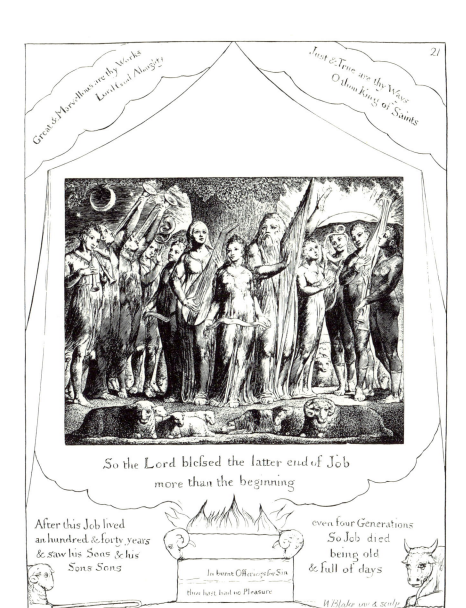

Great & Marvellous are thy Works Lord God Almighty

Just & True are thy Ways O thou King of Saints

So the Lord blefsed the latter end of Job more than the beginning

After this Job lived an hundred & forty years & saw his Sons & his Sons Sons

In burnt Offerings for Sin

thou hast had no Pleasure

even four Generations So Job died being old & full of days

W Blake inv & sculp

London Published as the Act directs March 8 1825 by William Blake Fountain Court Strand

Proof

INSCRIPTIONS ON THE ILLUSTRATIONS

The marginal inscriptions on the illustrations are all taken from the King James Bible. Blake's quotations are here given first; the corresponding original King James texts appear below them.

Some of Blake's variations seem to be slips of an imperfect memory, but others are intentional.

Blake's sudden capitalizings give unexpected emphases. The very placement of the inscriptions on the page may have significance. Sometimes the texts reading from top to bottom indicate the turbulent sequences of Job's ponderings (Illustration XI). In Illustration XII, the text hidden beneath the sleeping Humanity's head, from Job xxv : 6–7, indicates a conclusion not yet faced. In Illustration V, one can scarcely read the smaller letters of "And it grieved him at his heart" (Genesis vi : 6), a fragment the whole of which raises the problem of God's repentance.

Blake's punctuation, as usual, is often sparse, but sometimes it is so faint as not to appear in reproductions.

I

Our Father which art in Heaven | hallowed be thy Name

Our Father which art in heaven, Hallowed be thy name (Matthew vi : 9; Luke xi : 2)

Thus did Job continually

Thus did Job continually (Job i : 5)

There was a Man in the | Land of Uz whose Name | was Job & that Man | was perfect & upright | & one that feared God | & eschewed Evil & there | was born unto him Seven | Sons & Three Daughters

There was a man in the land of Uz, whose name was Job; and that man was perfect and upright, and one that feared God, and eschewed evil. And there were born unto him seven sons and three daughters (Job i : 1–2)

The Letter Killeth | The Spirit giveth Life

... the letter killeth, but the spirit giveth life (II Corinthians iii : 6)

It is Spiritually Discerned

... they are spiritually discerned (I Corinthians ii : 14)

II

I beheld the | Ancient of Days

I beheld ... the Ancient of days (Daniel vii : 9)

INSCRIPTIONS

Hast thou considered my Servant Job
Hast thou considered my servant Job (Job i : 8)

The Angel of the Divine Presence
> NOTE: This phrase does not appear in the Bible. It signifies Satan, who presents himself before the Lord (Job i : 6). The Hebrew letters beneath his name, however, identify him as "King Jehovah," Job's false God.

I shall see God
... shall I see God (Job xix : 26)

Thou art our Father
... thou art our father (Isaiah lxiv : 8)

We shall awake up | in thy Likeness
... when I awake, with thy likeness (Psalm xvii : 15)

When the Almighty was yet with me, When my Children | were about me
When the Almighty was yet with me, when my children were about me (Job xxix : 5)

There was a day when the Sons of God came to present themselves before the Lord & Satan came also among them | to present himself before the Lord
Now there was a day when the sons of God came to present themselves before the Lord, and Satan came also among them (Job i : 6)

III

The Fire of God is | fallen from Heaven
The fire of God is fallen from heaven (Job i : 16)

And the Lord said unto Satan Behold All that he hath is in thy Power
And the Lord said unto Satan, Behold, all that he hath is in thy power (Job i : 12)

Thy Sons & thy Daughters were eating & drinking Wine in their | eldest Brothers house & behold there came a great wind from the Wilderness | & smote upon the four faces of the house & it fell upon the young Men & they are Dead
Thy sons and thy daughters were eating and drinking wine in their eldest brother's house: And, behold, there came a great wind from the wilderness, and smote the four corners of the house, and it fell upon the young men, and they are dead (Job i : 18–19)

IV

And there came a Messenger unto Job & said The Oxen were plowing & the Sabeans came down & they have slain the Young Men with the Sword

And there came a messenger unto Job, and said, The oxen were plowing . . . And the Sabeans fell upon them . . . yea, they have slain the servants with the edge of the sword (Job i : 14–15)

Going to & fro in the Earth | & walking up & down in it

From going to and fro in the earth, and from walking up and down in it (Job i : 7)

And I only am escaped alone to tell thee

. . . and I only am escaped alone to tell thee (Job i : 15)

While he was yet speaking there came also another & said | The fire of God is fallen from heaven & hath burned up the flocks & the | Young Men & consumed them & I only am escaped alone to tell thee

While he was yet speaking, there came also another, and said, The fire of God is fallen from heaven, and hath burned up the sheep, and the servants, and consumed them; and I only am escaped alone to tell thee (Job i : 16)

V

Did I not weep for him who was in trouble? Was not my Soul afflicted for the Poor

Did not I weep for him that was in trouble? was not my soul grieved for the poor? (Job xxx : 25)

Behold he is in thy hand: but save his Life

Behold, he is in thine hand; but save his life (Job ii : 6)

Then went Satan forth from the presence of the Lord

So Satan went forth from the presence of the Lord (Job i : 12)

And it grieved him at his heart

. . . and it grieved him at his heart (Genesis vi : 6)

> NOTE: When God before the Flood saw the wickedness of man, "it repented the Lord that he had made man on the earth, and it grieved him at his heart" (Genesis vi : 6). Blake retranslated this sentence brilliantly: "He repented that he had made Adam (of the Female, the Adamah) & it grieved him at his heart" (*Laocoön*, Keynes, p. 776). The Elohim, the creator of men, blamed himself for giving man a mortal body from the female.

Who maketh his Angels Spirits & his Ministers a Flaming Fire

Who maketh his angels spirits; his ministers a flaming fire (Psalm civ : 4)

INSCRIPTIONS

VI

Naked came I out of my | mothers womb & Naked shall I return thither | The Lord gave & the Lord hath taken away. Blessed be the Name of the Lord

Naked came I out of my mother's womb, and naked shall I return thither: the Lord gave, and the Lord hath taken away; blessed be the name of the Lord (Job i : 21)

And smote Job with sore Boils | from the sole of his foot to the crown of his head

. . . and smote Job with sore boils from the sole of his foot unto his crown (Job ii : 7)

VII

What! shall we recieve Good | at the hand of God & shall we not also | recieve Evil

What? shall we receive good at the hand of God, and shall we not receive evil? (Job ii : 10)

And when they lifted up their eyes afar off & knew him not | they lifted up their voice & wept, & they rent every Man his | mantle & sprinkled dust upon their heads towards heaven

And when they lifted up their eyes afar off, and knew him not, they lifted up their voice, and wept; and they rent every one his mantle, and sprinkled dust upon their heads toward heaven (Job ii : 12)

Ye have heard of the Patience of Job and have seen the end of the Lord.

Ye have heard of the patience of Job, and have seen the end of the Lord (James v : 11)

VIII

Lo let that night be solitary | & let no joyful voice come therein

Lo, let that night be solitary, let no joyful voice come therein (Job iii : 7)

Let the Day perish wherein I was Born

Let the day perish wherein I was born (Job iii : 3)

And they sat down with him upon the ground seven days & seven | nights & none spake a word unto him for they saw that his grief | was very great

So they sat down with him upon the ground seven days and seven nights, and none spake a word unto him: for they saw that his grief was very great (Job ii : 13)

IX

Shall mortal Man be more Just than God? Shall a Man be more Pure than his Maker? Behold he putteth no trust in his Saints & his Angels he chargeth with folly

Shall mortal man be more just than God? shall a man be more pure than his maker? Behold, he put no trust in his servants; and his angels he charged with folly (Job iv : 17–18)

Then a Spirit passed before my face | the hair of my flesh stood up

Then a spirit passed before my face; the hair of my flesh stood up (Job iv : 15)

X

But he knoweth the way that I take | when he hath tried me I shall come forth like gold

But he knoweth the way that I take: when he hath tried me, I shall come forth as gold (Job xxiii : 10)

Have pity upon me! Have pity upon me! O ye my friends | for the hand of God hath touched me

Have pity upon me, have pity upon me, O ye my friends; for the hand of God hath touched me (Job xix : 21)

Though he slay me yet will I trust in him

Though he slay me, yet will I trust in him (Job xiii : 15)

The Just Upright Man is laughed to scorn

. . . the just upright man is laughed to scorn (Job xii : 4)

Man that is born of a Woman is of few days & full of trouble | he cometh up like a flower & is cut down, he fleeth also as a shadow | & continueth not. And dost thou open thine eyes upon such a one | & bringest me into judgment with thee

Man that is born of a woman is of few days, and full of trouble. He cometh forth like a flower, and is cut down: he fleeth also as a shadow, and continueth not. And dost thou open thine eyes upon such an one, and bringest me into judgment with thee? (Job xiv : 1-3)

XI

My bones are pierced in me in the | night season & my sinews | take no rest

My bones are pierced in me in the night season: and my sinews take no rest (Job xxx : 17)

My skin is black upon me | & my bones are burned | with heat

My skin is black upon me, and my bones are burned with heat (Job xxx : 30)

The triumphing of the wicked | is short, the joy of the hypocrite is | but for a moment

. . . the triumphing of the wicked is short, and the joy of the hypocrite but for a moment (Job xx : 5)

Satan himself is transformed into an Angel of Light & his Ministers into Ministers of Right-eousness

. . . for Satan himself is transformed into an angel of light. . . . his ministers also be transformed as the ministers of righteousness (II Corinthians xi : 14-15)

INSCRIPTIONS

With Dreams upon my bed thou scarest me & affrightest me | with Visions

Then thou scarest me with dreams, and terrifiest me through visions (Job vii : 14)

Why do you persecute me as God & are not satisfied with my flesh. Oh that my words | were printed in a Book that they were graven with an iron pen & lead in the rock for ever | For I know that my Redeemer liveth & that he shall stand in the latter days upon | the Earth & after my skin destroy thou This body yet in my flesh shall I see God | whom I shall see for Myself and mine Eyes shall behold & not Another tho consumed be my wrought Image

Why do ye persecute me as God, and are not satisfied with my flesh? Oh that my words were now written! oh that they were printed in a book! That they were graven with an iron pen and lead in the rock for ever! For I know that my redeemer liveth, and that he shall stand at the latter day upon the earth: And though after my skin worms destroy this body, yet in my flesh shall I see God: Whom I shall see for myself, and mine eyes shall behold, and not another; though my reins be consumed within me (Job xix : 22–27)

> NOTE: Blake's "tho consumed be my wrought Image" is a perfectly possible translation or interpretation of "though my reins be consumed within me."

Who opposeth & exalteth himself above all that is called God or is Worshipped

Who opposeth and exalteth himself above all that is called God, or that is worshipped (II Thessalonians ii : 4)

XII

For God speaketh once yea twice | & Man percieveth it not

For God speaketh once, yea twice, yet man perceiveth it not (Job xxxiii : 14)

In a Dream in a Vision of the Night | in deep Slumberings upon the bed

In a dream, in a vision of the night, when deep sleep falleth upon men, in slumberings upon the bed (Job xxxiii : 15)

Then he openeth the ears of Men & sealeth their instruction

Then he openeth the ears of men, and sealeth their instruction (Job xxxiii : 16)

That he may withdraw Man from his purpose | & hide Pride from Man

That he may withdraw man from his purpose, and hide pride from man (Job xxxiii : 17)

If there be with him an Interpreter One among a Thousand | then he is gracious unto him | & saith Deliver him from going down to the Pit | I have found a Ransom

If there be a messenger with him, an interpreter, one among a thousand . . . Then he is gracious unto him, and saith, Deliver him from going down to the pit: I have found a ransom (Job xxxiii : 23–24)

For his eyes are upon | the ways of Man & he observeth | all his goings

For his eyes are upon the ways of man, and he seeth all his goings (Job xxxiv : 21)

I am Young & ye are very Old wherefore I was afraid

I am young, and ye are very old; wherefore I was afraid (Job xxxii : 6)

Lo all these things worketh God oftentimes with Man to bring | back his Soul from the pit to be enlightened | with the light of the living

Lo, all these things worketh God oftentimes with man, To bring back his soul from the pit, to be enlightened with the light of the living (Job xxxiii : 29–30)

Look upon the heavens & behold the clouds | which are higher | than thou

Look unto the heavens, and see; and behold the clouds which are higher than thou (Job xxxv : 5)

If thou sinnest what | doest thou against him, or if thou be | righteous what givest thou unto him

If thou sinnest, what doest thou against him? . . . If thou be righteous, what givest thou him? (Job xxxv : 6–7)

XIII

Who is this that darkeneth counsel by words without knowledge

Who is this that darkeneth counsel by words without knowledge? (Job xxxviii : 2)

Then the Lord answered Job out of the Whirlwind

Then the Lord answered Job out of the whirlwind (Job xxxviii : 1)

Who maketh the Clouds his Chariot & walketh on the Wings of the Wind

. . . who maketh the clouds his chariot: who walketh upon the wings of the wind (Psalm civ : 3)

Hath the Rain a Father & who hath begotten the Drops of the Dew

Hath the rain a father? or who hath begotten the drops of dew? (Job xxxviii : 28)

XIV

Canst thou bind the sweet influences of Pleiades or loose the bands of Orion

Canst thou bind the sweet influences of Pleiades, or loose the bands of Orion? (Job xxxviii : 31)

When the morning Stars sang together, & all the | Sons of God shouted for joy

When the morning stars sang together, and all the sons of God shouted for joy (Job xxxviii : 7)

INSCRIPTIONS

Let there Be | Light
Let there be light (Genesis i : 3)

Let there be A | Firmament
Let there be a firmament (Genesis i : 6)

Let the Waters be gathered | together into one place | & let the Dry Land | appear
Let the waters under the heaven be gathered together unto one place, and let the dry land appear (Genesis i : 9)

And God made Two Great Lights | Sun | Moon
And God made two great lights (Genesis i : 16)

Let the Waters bring | forth abundantly
Let the waters bring forth abundantly (Genesis i : 20)

Let the Earth bring forth | Cattle & Creeping thing | & Beast
Let the earth bring forth the living creature . . . cattle, and creeping thing, the beast of the earth (Genesis i : 24)

XV

Can any understand the spreadings of the Clouds | the noise of his Tabernacle
Also can any understand the spreadings of the clouds, or the noise of his tabernacle? (Job xxxvi : 29)

Also by watering he wearieth the thick cloud | He scattereth the bright cloud also it is turned about by his counsels
Also by watering he wearieth the thick cloud: he scattereth his bright cloud: And it is turned round about by his counsels (Job xxxvii : 11–12)

Of Behemoth he saith, He is the chief of the ways of God
Behold now behemoth . . . He is the chief of the ways of God (Job xl : 15, 19)

Of Leviathan he saith, He is King over all the Children of Pride
. . . he is a king over all the children of pride (Job xli : 34)

Behold now Behemoth which I made with thee
Behold now behemoth, which I made with thee (Job xl : 15)

XVI

Hell is naked before him & Destruction has no covering
Hell is naked before him, and destruction hath no covering (Job xxvi : 6)

Canst thou by searching find out God | Canst thou find out the Almighty to perfection
Canst thou by searching find out God? canst thou find out the Almighty unto perfection? (Job xi : 7)

The Accuser of our Brethren is Cast down | which accused them before our God day & night
... the accuser of our brethren is cast down, which accused them before our God day and night (Revelation xii : 10)

It is higher than Heaven what canst thou do | It is deeper than Hell what canst thou know
It is as high as heaven; what canst thou do? deeper than hell; what canst thou know? (Job xi : 8)

The Prince of this World shall be cast out
... now shall the prince of this world be cast out (John xii : 31)

Thou hast fulfilled the Judgment of the Wicked
But thou hast fulfilled the judgment of the wicked (Job xxxvi : 17)

Even the Devils are Subject to Us thro thy Name. Jesus said unto them, I saw Satan as lightning fall from Heaven
... even the devils are subject unto us through thy name. And he said unto them, I beheld Satan as lightning fall from heaven (Luke x : 17–18)

God hath chosen the foolish things of the World to confound the wise | And God hath chosen the weak things of the World to confound the things that are mighty
But God hath chosen the foolish things of the world to confound the wise; and God hath chosen the weak things of the world to confound the things which are mighty (I Corinthians i : 27)

XVII

He bringeth down to | the Grave & bringeth up
... he bringeth down to the grave, and bringeth up (I Samuel ii : 6)

we know that when he shall appear we shall be like him for we shall see him as He Is
... we know that, when he shall appear, we shall be like him; for we shall see him as he is (I John iii : 2)

INSCRIPTIONS

When I behold the Heavens the work of thy hands the Moon & Stars which thou hast ordained, then I say, What is Man that thou art mindful of him? | & the Son of Man that thou visitest him

When I consider thy heavens, the work of thy fingers, the moon and the stars, which thou hast ordained; What is man, that thou art mindful of him? and the son of man, that thou visitest him? (Psalm viii : 3–4)

I have heard thee with the hearing of the Ear but now my Eye seeth thee

I have heard of thee by the hearing of the ear: but now mine eye seeth thee (Job xlii : 5)

He that hath seen me | hath seen my Father also

. . . he that hath seen me hath seen the Father (John xiv : 9)

I & my Father are One

I and my Father are one (John x : 30)

If you had known | me ye would have known my | Father also and | from henceforth | ye know him & | have seen him

If ye had known me, ye should have known my Father also: and from henceforth ye know him, and have seen him (John xiv : 7)

Believe me that | I am in the Father | & the Father in me

Believe me that I am in the Father, and the Father in me (John xiv : 11)

He that loveth me | shall be loved of | my Father

. . . he that loveth me shall be loved of my Father (John xiv : 21)

For he dwelleth in | you & shall be with | you

. . . for he dwelleth with you, and shall be in you (John xiv : 17)

At that day ye shall know that I am in | my Father & you in me & I in you

At that day ye shall know that I am in my Father, and ye in me, and I in you (John xiv : 20)

If ye loved me ye would rejoice | because I said I go unto the Father

If ye loved me, ye would rejoice, because I said, I go unto the Father (John xiv : 28)

He that loveth | me shall be loved | of my Father & I | will love him & | manifest myself | unto him

. . . he that loveth me shall be loved of my Father, and I will love him, and will manifest myself to him (John xiv : 21)

64

And my Father | will love him & we | will come unto him | & make our abode | with him

. . . and my Father will love him, and we will come unto him, and make our abode with him (John xiv : 23)

And the Father | shall give you | Another Comforter | that he may abide | with you for ever

And . . . the Father . . . shall give you another Comforter, that he may abide with you for ever (John xiv : 16)

Even the Spirit of Truth whom the World Cannot recieve

Even the Spirit of truth; whom the world cannot receive (John xiv : 17)

XVIII

Also the Lord accepted Job

. . . the Lord also accepted Job (Job xlii : 9)

And my Servant Job shall pray for you

. . . and my servant Job shall pray for you (Job xlii : 8)

And the Lord turned the captivity of Job when he prayed for his Friends

And the Lord turned the captivity of Job, when he prayed for his friends (Job xlii : 10)

I say unto you | Love your En|emies bless them | that curse you | do good to them | that hate you | & pray for them | that despitefull | use you | & persecute you

But I say unto you, Love your enemies, bless them that curse you, do good to them that hate you, and pray for them which despitefully use you, and persecute you (Matthew v : 44)

That you may be | the children of | your Father which | is in heaven, for | he maketh his sun | to shine on the E|vil & the Good & | sendeth rain on | the Just & the Unjust.

That ye may be the children of your Father which is in heaven: for he maketh his sun to rise on the evil and on the good, and sendeth rain on the just and on the unjust (Matthew v : 45)

Be ye therefor perfect as your Father which is in heaven is perfect

Be ye therefore perfect, even as your Father which is in heaven is perfect (Matthew v : 48)

XIX

The Lord maketh Poor & maketh Rich | He bringeth Low & Lifteth Up

The Lord maketh poor, and maketh rich: he bringeth low, and lifteth up (I Samuel ii : 7)

who provideth for the | Raven his Food | When his young ones cry unto God

Who provideth for the raven his food? when his young ones cry unto God (Job xxxviii : 41)

65

INSCRIPTIONS

Every one also gave him a piece of Money
... every man also gave him a piece of money (Job xlii : 11)

Who remembered us in our low estate | For his Mercy endureth for ever
Who remembered us in our low estate: for his mercy endureth for ever (Psalm cxxxvi : 23)

XX

How precious are thy thoughts | unto me O God | how great is the sum of them
How precious also are thy thoughts unto me, O God! how great is the sum of them! (Psalm cxxxix : 17)

There were not found Women fair as the Daughters of Job | in all the Land & their Father gave them Inheritance | among their Brethren
And in all the land were no women found so fair as the daughters of Job: and their father gave them inheritance among their brethren (Job xlii : 15)

If I ascend up into Heaven thou art there | If I make my bed in Hell behold Thou | art there
If I ascend up into heaven, thou art there: if I make my bed in hell, behold, thou art there (Psalm cxxxix : 8)

XXI

Great & Marvellous are thy Works | Lord God Almighty | Just & True are thy Ways | O thou King of Saints
Great and marvellous are thy works, Lord God Almighty; just and true are thy ways, thou King of saints (Revelation xv : 3)

So the Lord blessed the latter end of Job | more than the beginning
So the Lord blessed the latter end of Job more than his beginning (Job xlii : 12)

After this Job lived | an hundred & forty years | & saw his Sons & his | Sons Sons even four generations | So Job died | being old | & full of days
After this lived Job an hundred and forty years, and saw his sons, and his sons' sons, even four generations. So Job died, being old and full of days (Job xlii : 16–17)

In burnt Offerings for Sin | thou hast had no Pleasure
In burnt offerings and sacrifices for sin thou hast had no pleasure (Hebrews x : 6)

66